PABLO PICASSO

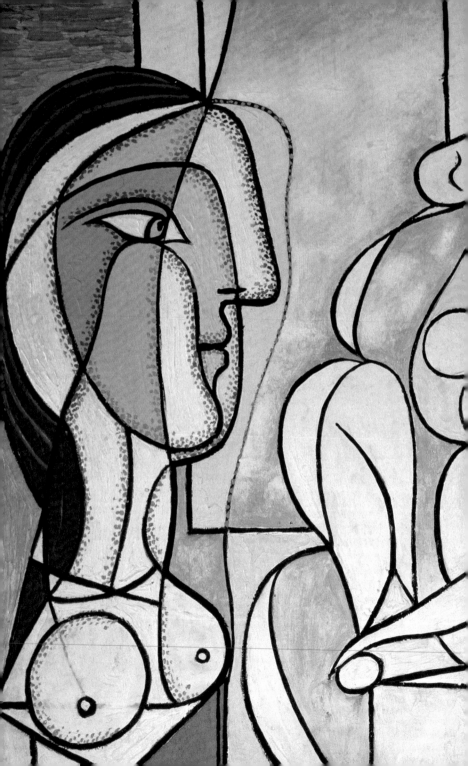

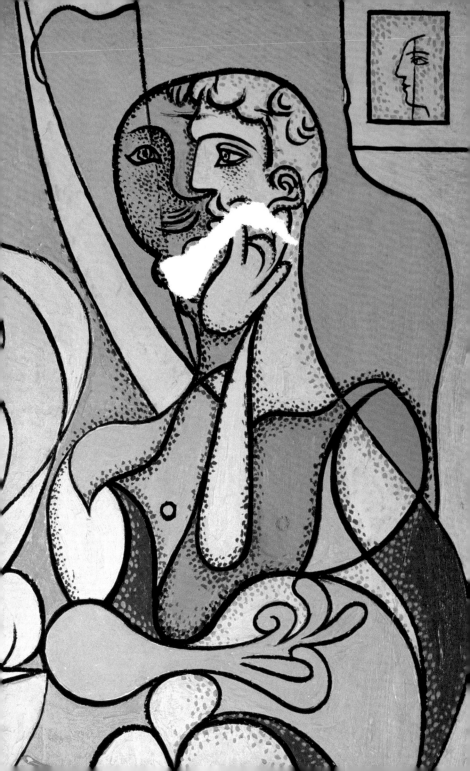

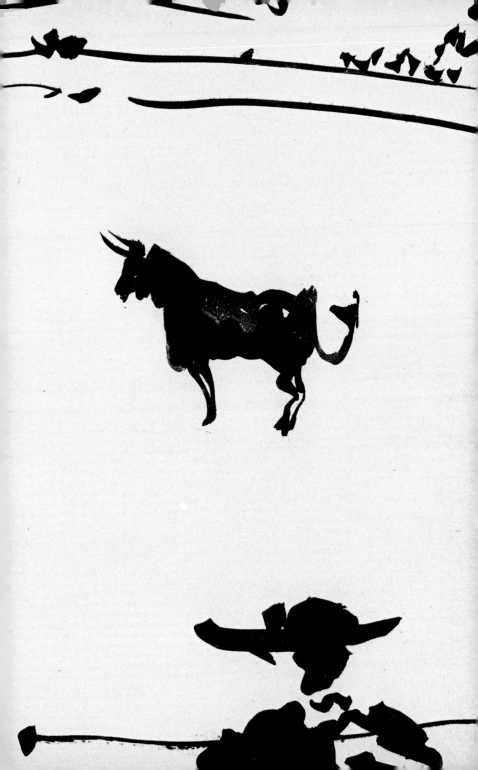

PABLO
PICASSO

WITH A CONTRIBUTION BY
Markus Müller

HIRMER

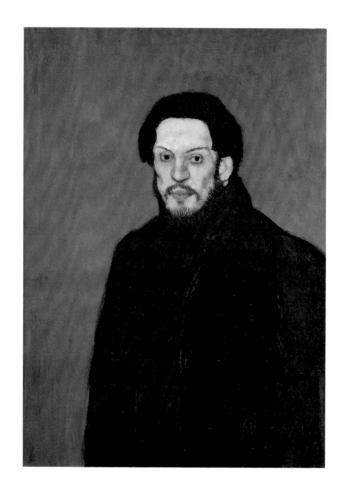

PABLO PICASSO

Self-Portrait with Coat, 1901

Oil on canvas, Musée Picasso, Paris

CONTENTS

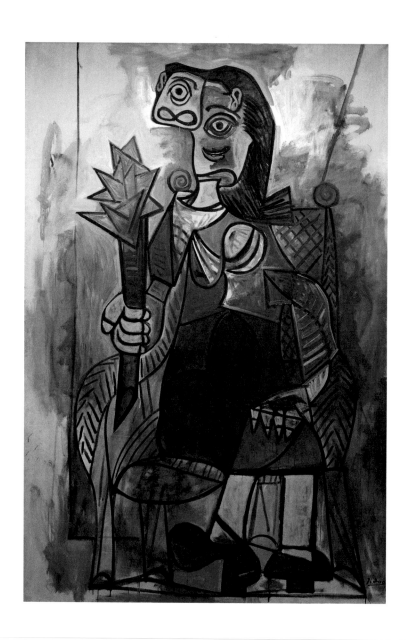

I *Woman with Artichoke*, 1941, oil on canvas
Museum Ludwig, Cologne

THE MANY METAMORPHOSES
OF THE MINOTAUR

Markus Müller

"When I was twelve, I drew like Raphael,"[1] said the mature Pablo Picasso in conversation. These words reflect the healthy self-assurance of an exceptional artist brought up and drilled as a prodigy. His unusual talent was noticed while he was still a child and made its way to the fore – altogether in the spirit of Giorgio Vasari and his Renaissance contemporaries, who in their lives of the great masters described the same idea of what it means to be an artist.

The young Picasso attained precocious artistic maturity under the instruction of his father, whom he immortalised at the age of 16 in the figure of the doctor on the left-hand side of the painting *Science and Charity* (2). This large painting is masterly in its artistic technique, but its aesthetics are rooted in the taste of the time. In the allegorical enhancement of what looks, on the surface, like a genre scene, the work is in the tradition of 'Anecdotal Realism'.[2]

OUTSIDERS AND OUTCASTS

Goethe's *Tasso* contains the lines "A talent does in stillness form itself – a character on life's perturbed stream." The truth of these words is confirmed not least by Picasso's artistic biography. After dropping out of his academic training in Madrid, Pablo Picasso moved to Paris, which was then the world capital of art, and with the help of his compatriot Pere

2 *Science and Charity*, 1897
Oil on canvas, Museu
Picasso, Barcelona

Mañach he was accorded his first solo exhibition at the Galerie Vollard in
1901. Picasso was still oscillating in these years between Barcelona and
Paris, having not yet decided which city offered the best prospects for him
and his art. On the occasion of the Vollard exhibition, the critic Félicien
Fagus had written that Picasso's paintings reminded him of the works of
Henri de Toulouse-Lautrec and Edgar Degas, among others. The observa-
tion certainly still seems accurate when we consider paintings like the 1902
The Blue Room (3). The intimate subject of the woman at her toilet owes
much to Degas, and Toulouse-Lautrec is recognisable as an artistic remi-
niscence in the form of the May Milton poster. In this and similar pictures,
Picasso was still searching for his ancestors and elective affinities, but he
appropriated the concepts of others as his own: "It's been said that in my
early years in Paris I copied Toulouse-Lautrec and Steinlen. That may be,
but never has anyone confused their paintings with mine."[3]
This appropriation process was supported by a consistent monochrome
stylisation of his art. A pronounced blue tonality now came to dominate
his works, which focused on the outsiders and outcasts on the fringes of
society in the modern metropolis. The poet Charles Baudelaire had al-
ready praised this aspect world of the modern city as a subject in tune with
the times. The blue implied – as the writer Alberto Moravia once appo-
sitely noted – simplification, stylisation and standardisation.[4] These are
elegiac figures, and the pathos of their suffering is subtly and artistically
exaggerated and stylised. The cryptic painting *La Vie* (4) is regarded as the

artistic culmination of this 'Blue Period'. In the male figure, Picasso has immortalised his fellow artist Carlos Casagemas, the central easel motif indicating his profession. Casagemas had committed suicide in February 1901 as a result of unrequited love. The work relates not just to this concrete event, but links it to an allegory of the different ages of man, and to the status of the artist, for in preliminary studies Picasso had still given his fellow artist his (Picasso's) own facial features.

ROPED TOGETHER

In 1904 Picasso's palette began to brighten up noticeably, and his pictures came increasingly populated with harlequin figures and circus characters as professional jesters. The pictures of this "Rose Period" (1904–1906), also known as the "Circus Period" as a result of the motifs, are reflections on the life of the artist, for their protagonists should be seen as symbolic of

3 *The Blue Room*, 1901, oil on canvas
The Phillips Collection, Washington

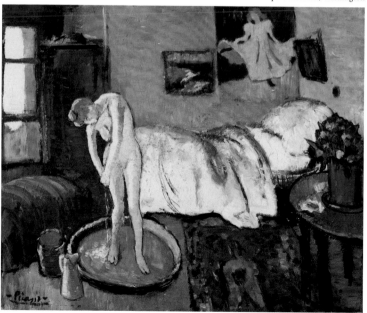

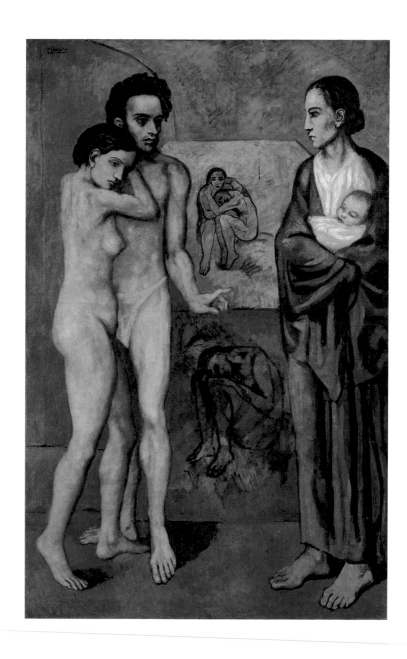

4 *La Vie*, 1903, oil on canvas
The Cleveland Museum of Art, Cleveland

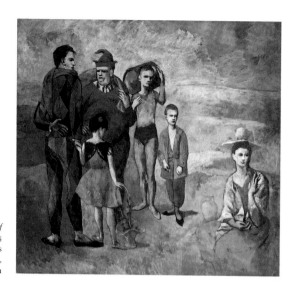

5 *The Family of Saltimbanques*, 1905
Oil on canvas
National Gallery of Art,
Washington

the professional artist. In this period, Picasso's art is related intellectually to that of his poet friends of the time.

The "Picasso gang" centred largely on André Salmon, Max Jacob and Guillaume Apollinaire. The latter is said to have coined the apposite description of the 1907 painting *Les Demoiselles d'Avignon* (6) as a "philosophical brothel". Picasso prepared this work in more than 800 preliminary studies. This veritable proliferation of studies, unique in the history of art, already points to the revolutionary explosiveness of the picture. The first drawings still show a male figure with a skull on the left-hand edge of the picture; he was interpreted as a medical student and in an alleged reference to the health risks of commercial sex, lent the picture an allegorical note. As the creative process proceeded, Picasso deleted this male figure and allowed the picture to be dominated entirely by the four women with their provocatively expressive poses. The large canvas is stylistically heterogeneous, which becomes obvious in the differentiated structure of the face. The heads of the two women on the right are drawn in an edgy, indented style reminiscent of African masks. In the summer of 1907, Picasso had visited the exhibition of works of tribal art at the Trocadéro in Paris, and some interpreters are inclined to see this as an aesthetic awakening. Other Picasso biographers by contrast see in this event a

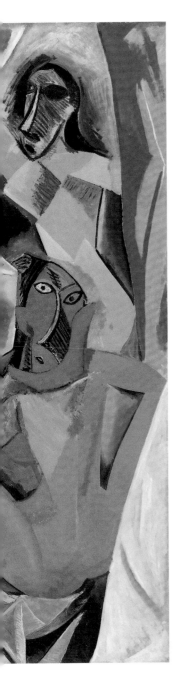

6 *Les Demoiselles d'Avignon*, 1907, oil on canvas
Museum of Modern Art, New York

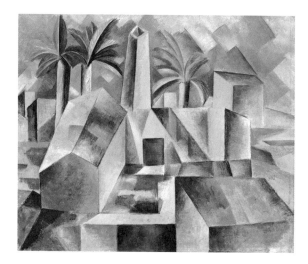

7 *Brick Factory in Tortosa*, 1909
Oil on canvas
State Hermitage Museum,
St Petersburg

8 *Still Life with Chair Caning*, 1912, oil on waxcloth mounted on canvas framed with cord, Musée Picasso, Paris

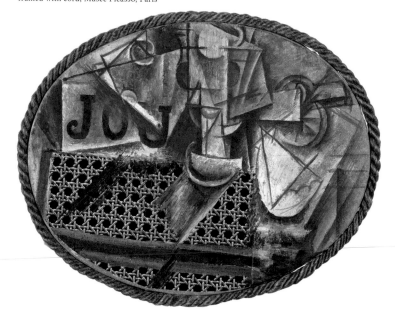

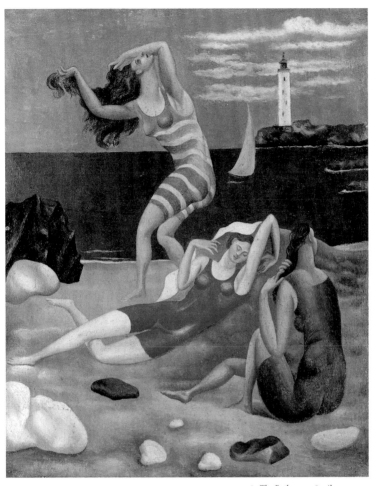

9 *The Bathers*, 1918, oil on canvas
Musée Picasso, Paris

confirmation of stylistic tendencies already churning subliminally in his work. The collecting of sub-Saharan African masks was altogether popular in Parisian artistic circles at the time, but it was indubitably the catalyst for the increasingly geometric stylisation and cuboid simplification of Picasso's pictorial vocabulary.

When he saw *Les Demoiselles d'Avignon*, Picasso's fellow artist Georges Braque had still observed that the picture had the same effect on the

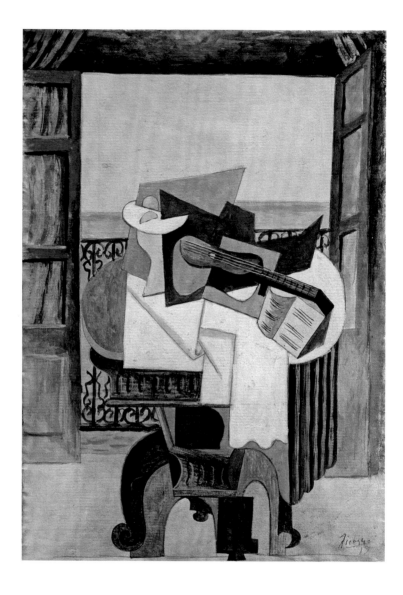

10 *Still Life with Guitar on a Table by an Open Window*, 1919, gouache and pencil on paper
Rosengart Collection, Lucerne

beholder as if the latter had been given paraffin to drink. In 1908 he began to communicate creatively with Picasso, and in their formal experiments the two cross-fertilised and stimulated each other. That same year, Henri Matisse noticed the omnipresence of 'cubes' in Braque's paintings, and the art critic Louis Vauxcelles took up this remark when discussing a Braque exhibition, coining the term "Cubism". Picasso dissected an object like a surgeon, according to Apollinaire, subjecting it to a scrupulous formal analysis that took the world of objects back to basic stereometric structures and transferred their three-dimensionality rigorously into the two-dimensionality of the picture plane. Picasso and Braque described themselves in these years as "roped together like mountaineers", an apposite description of their mutual dependency.

Picasso's formal experiments are more playful, effervescing in faster cascades. This led to his painting almost twice as many works in his Cubist phase as Georges Braque. But it was the latter who, time and again, gave the decided momentum to the Cubism they developed together. Thus it was Braque, who was originally trained as a house painter, who introduced to his pictures the stencil technique of using house painters' combs in 1911. Fragments of everyday reality now entered their pictorial world, along with letters, advertising, fabric and wallpaper patterns and sheet music. The analysis of forms in "Analytical Cubism" had become doctrinaire and hermetic, and in this later version of "Synthetic Cubism" the pictorial language of Braque and Picasso opened out into a new balance.

In the years immediately prior to the First World War, Cubism became such a broad artistic phenomenon in Paris that Picasso's poet friend Guillaume Apollinaire took up his pen to underscore the Spanish artist's authorship. In *Les Peintres cubistes* (The Cubist Painters), published in 1913, he wrote: "The great artistic revolution he has almost single-handedly accomplished is that the world is his new way of representing it."[5] In August 1914, at the station in Avignon, the rope that held Picasso and Braque together, and with it the great Cubist experiment, was to break: the latter was conscripted into the French army and returned from the war badly wounded. In letters written at the time to their joint dealer Daniel-Henry Kahnweiler, Braque expressed his surprise that Picasso had now created a new style, described as "Ingresque" In his art, Picasso executed a neo-Classicist about-turn, returning to an almost caricature-like plasticity which reached its climax in the early 1920s. The opulent female

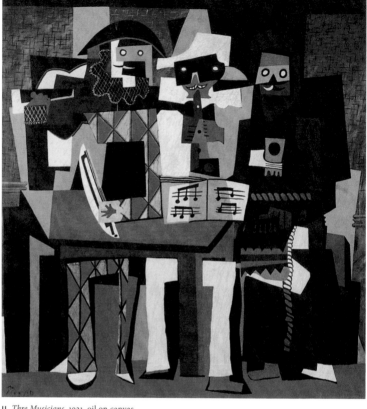

II *Thre Musicians*, 1921, oil on canvas
Philadelphia Museum of Art, Philadelphia

figures created by Picasso at this time were described by the writer Jean Cocteau as "femmes colosses". It was Cocteau, too, who set the tone for a return to aesthetic 'order' after the First World War with his "rappel à l'ordre" (recall to order). According to Cocteau, in matters of taste, France ought to return to her national identity, her Latin origins and her classical roots.

In 1917 Picasso had made the acquaintance of the Russian ballerina Olga Khokhlova, and not least through her, had discovered the world of the stage for himself and his art. He accompanied the Ballets Russes to Rome, Madrid, Barcelona and London. Picasso's life took on a glamorous note

that consigned the bohemian outlook of the early years in Paris to oblivion. His old poet friend Max Jacob spoke ironically of Picasso's 'Duchess Period'. After their marriage in July 1918, the couple spent the summer in the villa of a rich Chilean patroness in Biarritz. It was here that *The Bathers* (9) was painted, a work that betrayed the influence of Ingres in the mannered elongated bodies of the women. On the occasion of an exhibition in Paris devoted to the great French artist in 1905, critics had said of his *Grande Odalisque* that he had paid too little attention to female anatomy

12 *Three Women by the Spring*, 1921, oil on canvas
Museum of Modern Art, New York

13 *The Dancers*, 1925, oil on canvas
Tate Modern, London

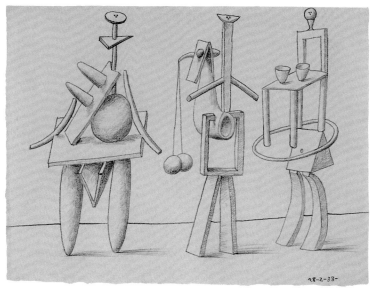

14 *Anatomical Studies: Three Women*, 1933, graphite on paper
Musée Picasso, Paris

and given his model one vertebra too many. In his Classical phase, Picasso now synthesised "Ingresque" and antique sources, among others, in a virtuoso manner. In the years following the First World War his style had been strangely undecided and exploratory. While up until then his work had been characterised by a radical, stringent development of a stylistic idiom, now the dialectic tension between different forms of artistic expression became the hallmark of his art. Thus in the summer of 1919 he painted Cubist still lifes in St. Raphael, composed in front of the traditional illusionist motif of the open window. In 1924 the *Surrealist Manifesto* was published in Paris, declaring the unconscious-libidinal aspect of human existence to be the driving force behind a radical expansion of consciousness. In the *Manifesto*, the definition of Surrealism included the phrase "Dictated by the thought, in the absence of any control exercised by reason". Surrealism was not a style, but rather an artistic attitude that deliberately claimed to oppose both civilisation and reason. André Breton, the doctrinal head of the Parisian movement, sought from the summer of 1923 to become more closely acquainted with Picasso and tried to charm

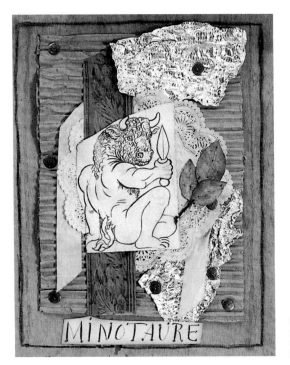

15 Draft for the title
page of *Minotaure*, 1933
Collage, Museum of
Modern Art, New York

him by repeatedly publishing his works in the Surrealists' programmatic
journals. In 1928 Breton: wrote: "For a number of reasons we thought him
to be one of us [...]"
Picasso created surreal-looking assemblages of objects which recall the
famous and influential line by the Comte de Lautréamont (the pseudonym
of the poet Isidore Lucien Ducasse) which talks of the "chance meeting on
a dissecting-table of an umbrella and a sewing-machine". His works in
these years were also marked by the biomorphic transformation of the
forms: doughily soft, deliquescent figures alternated with monstrously in-
flated bodies. In addition, Picasso acknowledged a great passion for bones
in conversations with the photographer Brassaï. "Have you noticed that
bones are always modelled [...]", he asked.

Picasso recognised the creative potential of Surrealist tendencies, without, however, becoming a compliant disciple of Breton's doctrines. He resisted any doctrinaire restrictions on his art, but made use of both the formal and thematic aspects of Surrealism in subjective interpretation and selective reading. Thus in 1928 the classical figure of the Minotaur began to appear on his pictorial stage, and he used it to create an individual mythology. The Parisian Surrealists followed the great founders of modern psychoanalysis such as Sigmund Freud and Carl Gustav Jung in their assessment of the classical myth as the key to the collective unconscious. Pablo Picasso now found in the bull-man a mythological projection figure for autobiographical statements: humanly fragile, but at the same time driven by animal urges, the Minotaur embodies the dual aspect of Picasso's personality. This mythological self-encoding now became a strategy that Picasso was to use in later creative periods too. As an old man, the artist once reflected: "If you mark on a map all the stations I have passed through, and

16 *Faun Uncovering a Sleeping Woman*, 1936, aquatint and scraper
Musée Picasso, Paris

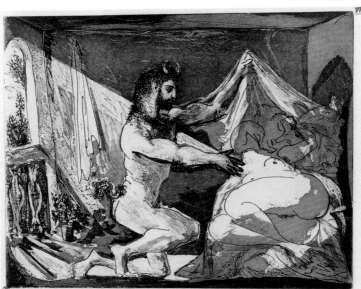

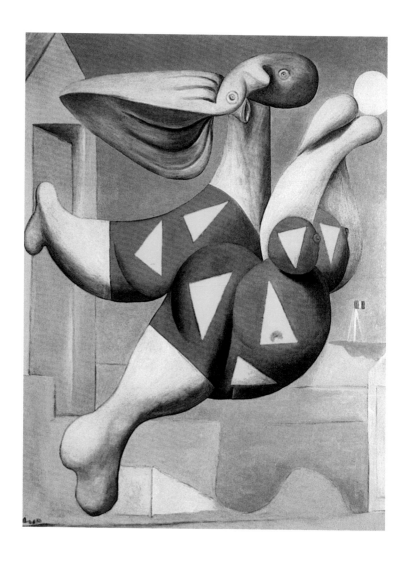

17 *Bather with Beach Ball*, 1932, oil on canvas
Museum of Modern Art, New York

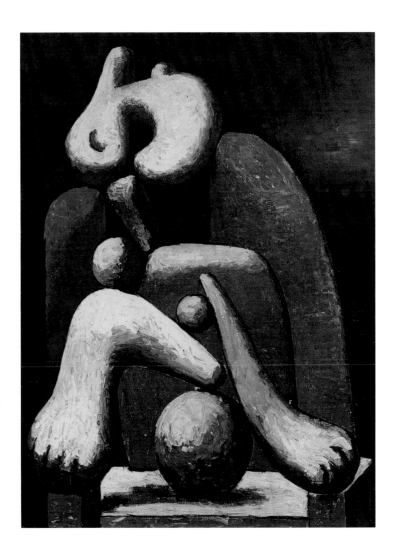

18 *Woman in Red Armchair*, 1932, oil on canvas
Musée Picasso, Paris

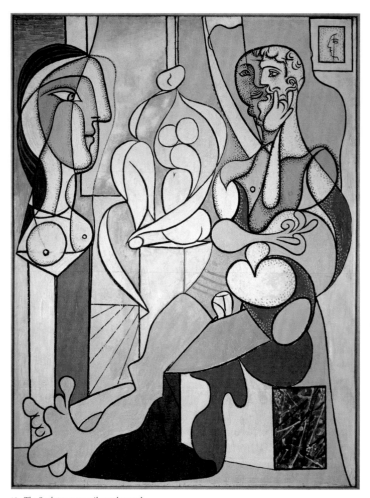

19 *The Sculptor*, 1931, oil on plywood
Musée Picasso, Paris

connect them with a line, maybe the result would be a Minotaur."[6] Since
1927 Picasso had been pursuing an extramarital affair with the young
Marie-Thérèse Walter, who was to introduce a basic mood of serene tran-
quillity into his works of the 1930s as the blonde muse. When his child-
hood friend and long-time private secretary Jaime Sabartés noted that
Picasso's art followed the curves of his loves, this was certainly no exagger-

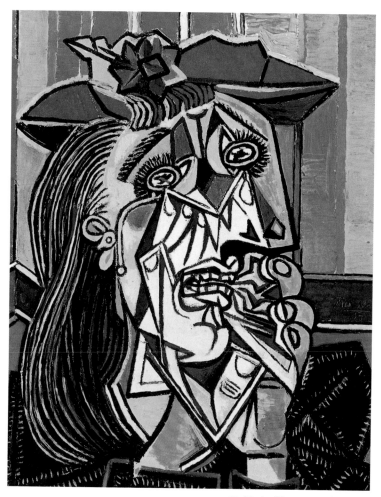

20 *Weeping Woman*, 1937, oil on canvas
Tate Modern, London

ation.[7] It was above all motifs of organic growth and fertility that he asso-
ciated pictorially with this model. In particular her classical profile fea-
tures in countless paintings, drawings and sculptures too, which in turn
became the motifs of paintings as artistic self-quotations. *The Sculptor* (19)
combines Cubist multiple perspective and surreal figure metamorphosis
with the theme of the classical-looking sculptor. Such a virtuoso stylistic

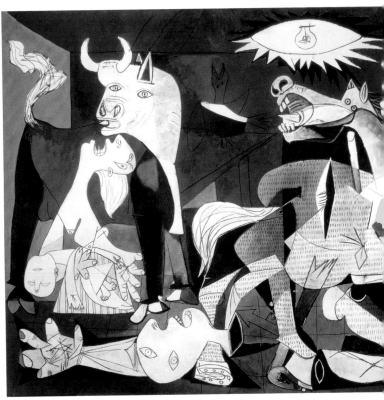

21 *Guernica*, 1937, oil on canvas, Museo Nacional Centro de Arte Reina Sofía, Madrid

pluralism was to become increasingly characteristic of the "Picasso style" in the 1930s.

In the middle of the decade Picasso met the photographer Dora Maar, who moved in Surrealist circles in Paris. He found a new formal vocabulary for her fragile, eccentric personality. In the *Weeping Woman* (20) he immortalised her in impressive fashion. The muse is depicted in a distorted image recalling an ambiguous puzzle picture, her psychological sensitivity being formally translated into expressive deformations.

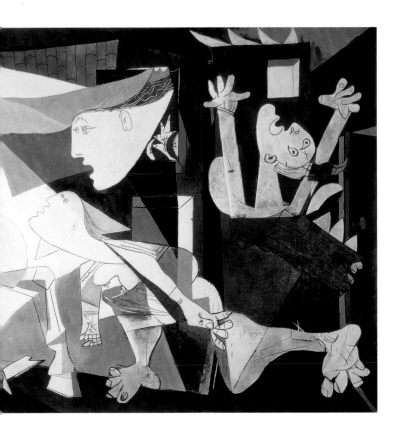

SPANISH CIVIL WAR

With the monumental painting *Guernica* (21), created in the spring of 1937, Picasso secured himself a lasting place in the collective pictorial memory of the twentieth century as a Spanish artist. Originally he planned a different subject for this commission for the Spanish Pavilion at the Paris World Fair, but the bombing of the Basque town of Guernica on 26 April 1937 made him change his mind. The powerful painting combines numerous registers and traditions of representation, thereby linking reminiscences of history painting and Christian iconography with motifs from the popular pictorial propaganda of the Spanish Civil War. The source of the suffering and destruction is not made explicit in the picture, and hence lies

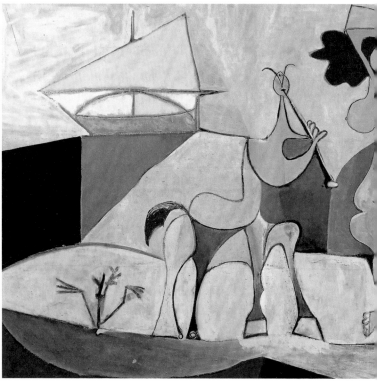

22 *The Joy of Life*, 1946, oil on hardboard, Musée Picasso, Antibes

solely in the beholder's imagination. *Guernica* unites elements and aspects of an allegorical history painting without however alluding to a specific wartime event. In this way Picasso has created a timelessly valid image of the horrors of war which, in its message, cannot be reduced to the evocation of a particular event. Picasso spent the war years largely isolated in Paris. The tonality of his pictures became noticeably darker. Against the background of the events, he brought to life the tradition of the still life, the objects becoming expressive bearers of the mood of these years. He once said to Pierre Daix: "You see, a cooking pot can also scream. Everything can scream. A simple bottle and Cézanne's apples."[8]

Shortly after the liberation of Paris and on the eve of the major exhibition *Le Salon de la libération*, it was announced that Picasso had joined the

French Communist Party. His fellow artist Marc Chagall was to note sardonically that his art found less favour in the Soviet Union than in the capitalist world.

POSTWAR ENTHUSIASM

After the Second World War, Picasso had become the star of the international art world and the most-photographed artist of his age. He was also a master of self-staging in film and photography. He staged not only his art, but also his life as a creative, exceptional individual. On a 1946 photo taken by Robert Capa, he is shown carrying a parasol, like a page to his young

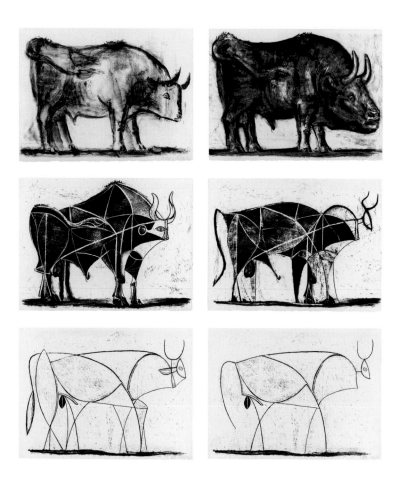

muse Françoise Gilot, stylised by this gesture into the lady of the house. The photograph was taken on the beach at Antibes, where he had been given the use of Château Grimaldi for a few months as a studio (48). The works of this period play cheerfully with classical motifs. The hybrid creatures – satyrs and fauns, and not least the Minotaur – were a good match for Picasso's own mercurial personality. After all, no less a commentator than Nietzsche had described the satyr as a sublime divine being, the epitome of the Dionysian spirit. The work *The Joy of Life* (22), which was painted in Antibes, represents a pictorial homage to the young muse at the focus of this frolicsome Dionysian line-up. Antibes can trace its history

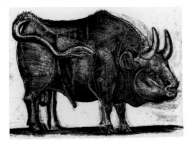
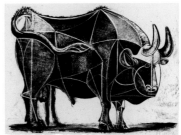
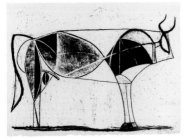
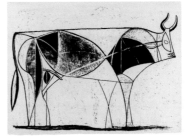
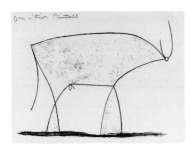

23 Lithograph series *The Bull*, 1946
Kunstmuseum Pablo Picasso Münster

back to ancient Greek times, and the painting bears the name 'ANTIPOLIS'. Against the background of his new private happiness and the general feeling of optimism now that the war had ended, Picasso discovered lithography as a technique for his art. The series *The Bull* (23) epitomises his pictorial thought process: for him, the journey is the destination. The naturalistically depicted young bull is successively dissected and reduced to the barest possible form. It was only for this eleventh and final state that the artist gave the go-ahead for it to be printed, the *bon à tirer* for an edition of 50. As in the present case, the different states of Picasso's prints, in particular, allow intimate insights into his pictorial thinking. As a rule he did not

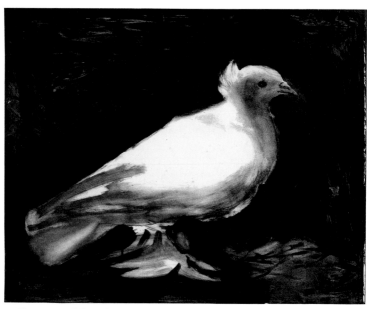

24 *The Dove*, 1949, lithograph, Kunstmuseum Pablo Picasso Münster

start out with a definitive idea, but only concretised it in the course of the creative process. "A picture is not completely thought out and laid down from the outset," he once said. "While I work on it, it changes as my thoughts change."⁹

In 1949 the lithograph *The Dove* (24), produced as a poster for a peace congress, was to enjoy an international triumph. Picasso suggests the tenderness and fragility of the bird in masterly fashion through the puffed up plumage in the nape. The reception history of this print does not in fact accord with the artist's original intentions. His friend and party comrade, the writer Louis Aragon, had chosen the work in Picasso's studio for an international peace conference. The Spanish for "dove" is "paloma", and Paloma was also the name Picasso gave in April 1949 to his daughter from the liaison with Françoise Gilot, following the birth of a son, Claude, in 1947.

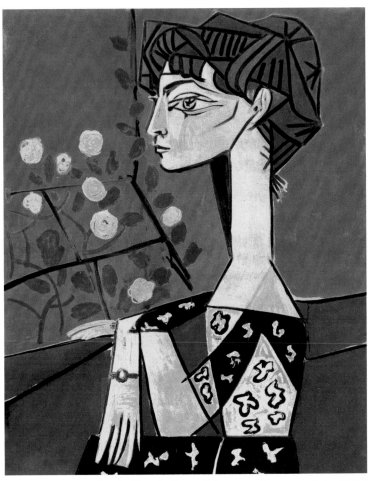

25 *Portrait of Jacqueline Roque with Roses*, 1954, oil on canvas, private collection

INNER LANDSCAPES

The family bliss was not to endure, however. In 1953/54 Françoise Gilot left
Picasso, which plunged him into a deep crisis. Hitherto, it was always he
who had abandoned his muses, and the converse did not fit into his mas-
culine agenda. He turned to his art for therapy. The result was the *Verve
Suite*, a series of 150 drawings revolving around the theme of the artist and

26 *To the Bullfight* (*Tauromaquia*, sheet 2), 1957 Aquatint, Classen Collection in the Kunstmuseum Pablo Picasso Münster

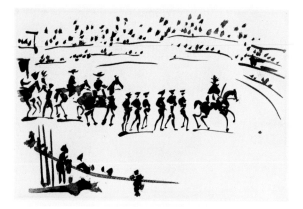

27 *The Entry of the Toreadors* (*Tauromaquia*, sheet 3), 1957 Aquatint, Classen Collection in the KPPM

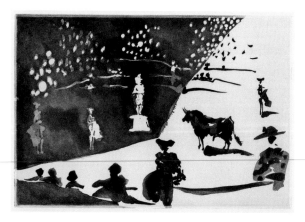

28 *Don Tancredo* (*Tauromaquia*, sheet 4), 1957 Aquatint, Classen Collection in the KPPM

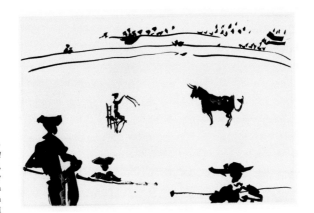

29 *The Bande-rillas, Seated (Tauromaquia, sheet 15), 1957* Aquatint, Classen Collection in the KPPM

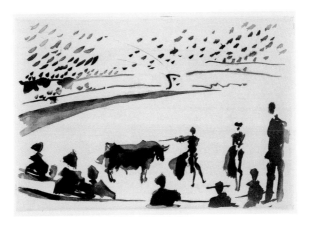

30 *Aiming for the Kill (Tauromaquia, sheet 19), 1957* Aquatint Classen Collection in the KPPM

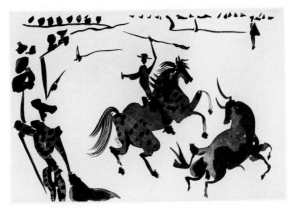

31 *Bullfight on Horseback with Spear (Tauromaquia, sheet 26), 1957* Aquatint, Classen Collection in the KPPM

his model (p. 73). At the latest since the prints created in the early 1930s for the novella The *Unknown Masterpiece* by Honoré de Balzac, which has art as its subject, the creative duo of artist and model had been a central topic in Picasso's pictorial world. He reflects here on the artistic transformation of the world, and on erotic love, and so the "studio picture" touches on two of the fundamental themes of his life. Picasso called his studio pictures "paysages d'intérieur" or "inner landscapes"' The "studio picture", in the judgement of Michel Leiris, had for Picasso the status of a genre in its own right, having a pronounced confessional character, showing as it were the magnified epidermis of the artist and including artistic theories in the guise of staged painterly practice.

A new woman entered Picasso's life in the person of Jacqueline Roque. For the last twenty years of his creative life, she was to become a fixture around whom most of his works would revolve. The *Portrait of Jacqueline Roque with Roses* (25), dating from June 1954, was a masterpiece. It comes across as a secular 'Madonna in the Rose Bower' and still fits into the typology of the female figure with an elongated neck in the mannered style of the depictions of Françoise Gilot and the young model Sylvette David. On account of her Mediterranean physiognomy and her classical profile, Picasso also called Jacqueline "the Spanish Woman". Thereafter the profile became the preferred view for her portraits.

The bullfight was without a doubt one of Picasso's life themes; he had been an aficionado of this Spanish folk spectacle since his childhood. Hélène Parmelin, a confidante of Picasso, noted: "Bulls are in the depths of his soul. The bullfighters are his cousins. The arena is his home."[10] Time and again, the fight ritual was given a semantic charge by Picasso – as a symbolic battle of the sexes and ultimately also as a metaphor for his own profession as artist and the existential threat that this posed.

32 *Las Meninas (after Velázquez)*, 1957, oil on canvas
Museu Picasso, Barcelona

In the late 1950s, Picasso created series of variations on, and paraphrases of, prominent works of art history. *Las Meninas* by Diego Velázquez became in 1957 the spark that ignited a gigantic cycle of variations. In 1960, by contrast, he dissected Edouard Manet's *Luncheon on the Grass*.

The way in which Picasso appropriated art history and its masterworks has been described as 'painterly cannibalism'.[11] While writers such as Douglas Cooper see this treatment of museum art as a self-confident expression of artistic dominance, others interpret it as a sign of decline, indicating that Picasso was working his way through the history of art because his powers of imagination were failing. "I paint against the canvases that count for me, but I also paint with what is missing from them," Picasso once said to André Malraux in an explanation of the compensatory importance of his paraphrases.[12]

With his free variations on the basis of prominent originals, Picasso turned the academic logic of his formative years on its head: practising on what were seen as exemplary styles and individual pictures here gives way to an artistic vendetta on the part of the later artist vis-à-vis his ancestors and

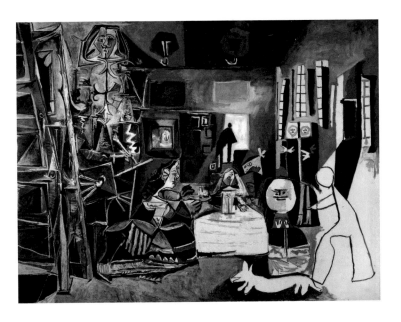

33 *Luncheon on the Grass*, 1960, oil on canvas, Musée Picasso, Paris

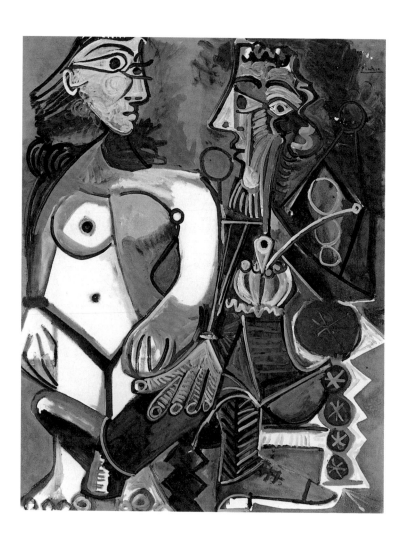

34 *Standing Nude and Seated Man with Pipe*, 1968, oil on canvas
Rosengart Collection, Lucerne

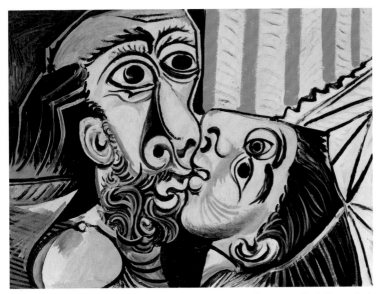

35 *The Kiss*, 1969, oil on canvas, Musée Picasso, Paris

mentors. "I have less and less time, and more and more to say,"[18] com-
plained Picasso in later years. From about the mid-1960s, he developed a
set of abbreviations consisting of ellipses and graphic signs. He described
this painterly syntax to Hélène Parmelin as follows: "A dot [...] for the
breast, a dash for the painter, five spots of colour for a foot ... That's
enough, don't you think?"[14] The paintings are often executed wet-in-wet,
while the white of the canvas was often an integral part of the compo-
sition.

The works revolve constantly around the theme of sexuality in a positively
obsessive fashion, which all too quickly led critics to dismiss this as a
purely compensatory act and an old man's fantasy. "Art is never chaste,"
declared Picasso, and when it was chaste, it was not art.

Time and again he now invoked the great painters of the Baroque in the
persons of Velázquez and Rembrandt. They served him as historical yard-
sticks for his own fame as an artist. Without a doubt these works are also
painterly reflections on the historicity of his own œuvre, for Picasso had
become a legend in his own lifetime, and contemporary currents and
trends were now drifting past him.

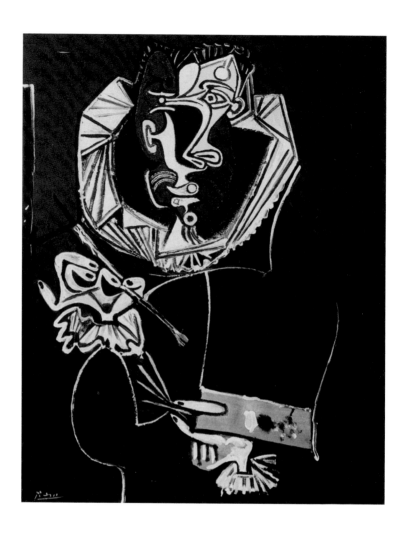

36 *Portrait of a Painter (after El Greco)*, 1950, oil on plywood
Rosengart Collection, Lucerne

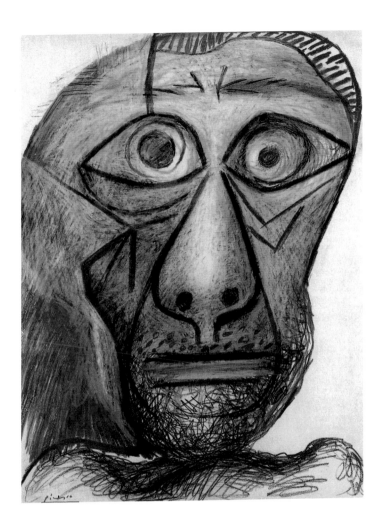

37 *Self-portrait (Head)*, 1972, chalk on paper
Fuji Television Gallery, Tokyo

On the occasion of the artist's 75th birthday, the great American art critic Clement Greenberg had written that Picasso had become a victim of the myth propagated by his admirers. Greenberg went on to note that Picasso's work had ceased to be indispensable for contemporary art. This may have been true of the tendencies in American art during the 1950s and 60s, but it ignores the fact that Picasso's œuvre had become the standard by which modern art *per se* had come to be measured.

Picasso has been accused of merely passing through all the important styles of the twentieth century like a tourist. In his text *Concerning the Spiritual in Art*, Picasso's fellow artist Wassily Kandinsky made the following judgement: "Tossed hither and thither by the need for self-expression, [Picasso] hurries from one manner to another."[15] The rapid transformation, the discontinuity, seem to be the only constants in his work. Picasso's biographer Pierre Daix once described this in the image of the 'metamorphosis machinery' that characterised his art. But Picasso is not only the great virtuoso of form. Biography and art are for him intimately intertwined; his work is marked by an almost monomaniac inclination towards self-reflection. Artistic crises become life crises, and conversely private happiness lends the œuvre a decisive impetus and new directions. Picasso's 'need for self-expression', the autobiographical roots of his art, gives it an existential profundity that retains its relevance across all fashions and styles.

MARKUS MÜLLER *has been the director of the Kunstmuseum Pablo Picasso in Münster since it was opened in 2000. Alongside numerous publications on Picasso and the art of the twentieth century, he has taught art history at the University of Münster since 2003, and has curated various exhibitions in France and Italy.*

1 Marie-Laure Bernadac and Androula Michael (eds.), *Picasso. Propos sur l'art*, Paris 1998, p. 171.
2 Cf. Carsten-Peter Warncke, in: Ingo F. Walther (ed.), *Pablo Picasso. 1881–1973*, Cologne 1995, p. 54.
3 Ibid. p. 56.
4 Brigitte Léal, Christine Piot and Marie-Laure Bernadac, *Picasso. La monographie 1881–1973*, Paris 2000, p. 47.
5 Guillaume Apollinaire, *The Cubist Painters*, trans. Peter Read, Berkeley and Los Angeles 2004, p. 38.
6 Romuald Dor de la Souchère, *Picasso à Antibes*, exh. cat. Antibes, Musée Picasso, Paris 1960, p. 66.
7 Brassaï, *Conversations with Picasso*, Chicago 1999, p. 135.
8 Léal/Piot/Bernadac 2000 (see note 4), p. 360.
9 *Picasso über Kunst. Aus Gesprächen zwischen Picasso und seinen Freunden*, ausgewählt von Daniel Keel, Zurich 1988, p. 19.
10 Hélène Parmelin, *Picasso says*, London 1969, p. 80.
11 Léal/Piot/Bernadac 2000 (see note 4), p. 405.
12 Anne Baldassari, 'La peinture de la peinture', in: *Picasso et les maîtres*, exh. cat. Paris 2008, pp. 20–35, here p. 32.
13 Léal/Piot/Bernadac 2000 (see note 4), p. 464.
14 Ibid., p. 464.
15 Wassily Kandinsky, *On the Spiritual in Art*, trans. with intro. by Michael T. H. Sadler, [1912] New York 2015, p. 18.

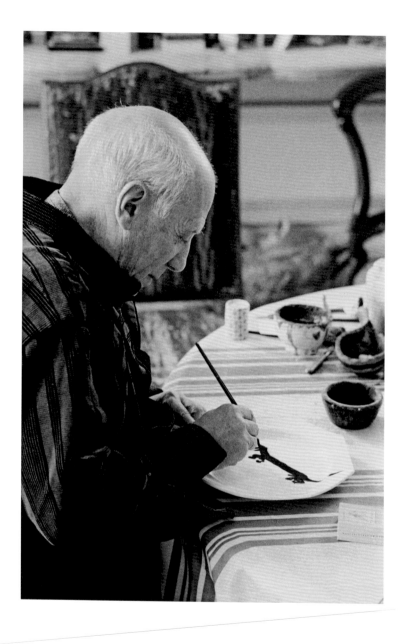

38 Picasso paints a pottery plate with the motif of his dachshund Lump
Villa La Californie, 1957

BIOGRAPHY

Pablo Picasso
1881 – 1973

1881 On 25 October Pablo Ruiz Picasso is born in Málaga, Spain. His mother, María Picasso y López, comes from Andalusia, his father, José Ruiz Blasco, from the province of León. He is a painter working as a teacher of drawing at the local college of applied arts and as a conservator at the municipal museum.

1884–1889 In December 1884 Pablo's sister Dolorès (Lola) is born, followed three years later by another sister, Concepción (Conchita), who dies in infancy. At the age of about seven, Pablo begins to paint under the guidance of his father. In 1889 he produces his first known oil painting, *Picador*, on the theme of the bull-fight.

1891–1894 The family moves to La Coruña, where the father has been appointed professor at the art college. At the age of ten, Pablo is also admitted there. In 1894 he begins to sign his works "P. Ruiz".

1895/96 In the spring of 1895, Pablo's father obtains the post of teacher at the art academy in Barcelona, and the rest of the family moves there later in the year. 14-year-old Pablo easily passes the entrance exam at the academy, and is excused the initial classes. Here he meets Manuel Pallarés, with whom he is to remain lifelong friends. In 1895/96 he paints his first large oil, *First Communion*, which is exhibited in Barcelona. In 1896 he moves into the first studio of his own in Barcelona together with Pallarés.

1897/98 Picasso produces his second large oil-painting, *Science and Charity*. He enrols at the San Fernando Royal Academy in Madrid, but leaves again in disappointment shortly afterwards and returns in 1898 to Barcelona. During a trip to the Catalan town of Horta de Ebro lasting several months, he executes numerous landscape studies.

1899 Back in Barcelona, he makes important contacts with artists and intellectuals at the cabaret Els Quatre Gats, and meets the painter Carlos Casagemas as well as his future secretary and close friend, the poet Jaime Sabartés. He makes his first etching, *El Zurdo*.

1900 Together with Casagemas he moves into a new studio in Barcelona. In his first exhibition in Els Quatre Gats, Picasso shows some 150 drawings and the painting *Derniers moments*, with which he also participates in the Paris World Fair. While in Paris he sees works by Paul Cézanne, Edgar Degas, Paul Signac, Henri de Toulouse-Lautrec and Edouard Vuillard. He meets the art dealers Berthe Weill and Pedro Mañach; the latter puts him under contract and pays a fixed monthly sum for his pictures.

1901 Suffering from unrequited love, Casagemas takes his own life on 17 February in Paris. Picasso's grief at his friend's death is manifested in a number of paintings. On 24 June Picasso's first Paris exhibition opens in the Galerie Ambroise Vollard. He sells 15 of the 64 paintings even before it opens. In the context of the exhibition he meets the writer Max Jacob, who will become a close friend. His pictures from now on are signed simply with his mother's surname "Picasso". Beginning of the so-called "Blue Period".

1902/03 In January Picasso returns to Barcelona. Here he meets the sculptor Julio González and creates his first sculpture *Femme assise*. In October he goes to Paris once more. His precarious financial situation means his work is largely in the form of drawings, as he cannot afford canvases. Mañach organises an exhibition in Berthe Weill's gallery in which pictures from the Blue Period are on view. After Picasso's return to Barcelona in 1903 he paints more than 50 pictures in the next 14 months, including *La Vie*.

1904 Picasso finally moves to Paris permanently and takes over a studio in the so-called Bateau-Lavoir, a dilapidated artist building in Montmartre, which he keeps until 1909. He meets the writer André Salmon and the poet and art critic Guillaume Apollinaire, with both of whom he soon becomes friends. In autumn he meets Fernande Olivier, who becomes first his model and later (until 1912) his lover. Clovis Sagot becomes Picasso's main dealer; in November, he exhibits for the last time in Berthe Weill's gallery. Start of the "Pink Period".

1905/06 Picasso exhibits Pink Period pictures at the Galerie Serrurier for the first time. The writer Gertrude Stein, whose salon Picasso frequents, becomes an important collector of his work, which improves his difficult financial situation. In 1906 he meets Henri Matisse and André Derain, both of them Fauves. Vollard buys some 30 Pink Period paintings. The proceeds enable Picasso to take Fernande to see his parents in Barcelona and then to travel to Gósol in the Pyrenees to paint and draw. When typhoid breaks out there, they return to Paris in August, earlier than planned.

1907/08 At the beginning of May Picasso meets the painter Georges Braque, and soon an intense and fruitful friendship develops. Picasso experiences the African sculptures he sees at the Musée de l'Homme in the Palais du Trocadéro as a "revelation". In the summer he completes his painting *Les Demoiselles d'Avignon*, which triggers general confusion. It is not publicly exhibited until 1916. Picasso meets the German art dealer Daniel-Henry Kahnweiler, who is enthusiastic about his work and will later become his dealer. From 1908, the style developed by Braque and Picasso becomes known as "Cubism".

1909–1911 Picasso and Fernande spend the summer of 1909 in Horta de Ebro, where he experiences the most productive and important phase of his career. At the end of that year, he comes into contact with the Futurists. In 1910/11 he is represented at exhibitions in Budapest, Paris, Düsseldorf, Munich, London, Berlin and New York.

1912/13 Picasso's relationship with Fernande deteriorates and the couple separate. Picasso takes up with Eva Gouel. His creates his first collage, *Still Life with Chair Caning*, taking up the technique of 'papiers collés' first developed by Braque. His work transitions from Analytic to Synthetic Cubism. Picasso moves from Montmartre to Montparnasse. At the end of the year he agrees to a three-year exclusive contract with Kahnweiler. Important solo and group exhibitions take place, and his works can be seen for example at the Blauer Reiter in Munich, at the Berlin Secession, at the Sonderbund exhibition in Cologne, as well as in London, Moscow, New York and Amsterdam. The first major retrospective is held in February 1913 at the Galerie Thannhauser in Munich. On 3 May, Picasso's father

dies. Together with Eva, he spends the summer in Céret, where he meets the Spanish painter Juan Gris.

1914/15 Picasso travels to Avignon with Eva in the summer, where he paints pictures in luminous colour with a tendency towards Pointillism. August sees the outbreak of the First World War, Braque and Derain are conscripted, while Apollinaire enlists as a volunteer. Kahnweiler's gallery is confiscated along with its entire contents. Picasso's palette becomes darker. As a result of Picasso's presence in German collections and his links with Kahnweiler, Cubism is increasingly associated with the enemy, Germany, and meets with rejection. In 1915 he meets Amedeo Modigliani, Giorgio de Chirico, Diego Rivera and the poet Jean Cocteau. On 14 December Eva dies of cancer.

1916/17 Cocteau introduces Picasso to Sergei Diaghilev, the impresario of the Ballets Russes; Picasso designs costumes and stage sets for the planned ballet *Parade*. In 1917 Picasso tours with the company on occasion and falls in love with Olga Khokhlova, a Ukrainian solo dancer. Together with Olga, who leaves the ensemble for Picasso, he returns to Paris.

1918/19 The link with the Ballets Russes and not least his friendship with the wealthy Eugenia Errázuriz from Chile, who buys important works by him, give Picasso entry to Parisian society. On 12 July Picasso and Olga marry, and spend the summer in Biarritz. He moves with Olga to an apartment near the Champs-Elysées and sets up a studio on the floor above. In 1919 Picasso begins to work on designs for the set of Stravinsky's ballet *Pulcinella*. A neo-classical tendency begins to show itself in his works.

1920/21 In summer 1920, Picasso and Olga travel to the Côte d'Azur, where he creates gouaches with motifs from the commedia dell'arte, as well as landscapes, nudes and works on mythological and antique themes. On 4 February 1921 their son Paul (Paulo) is born. The first Picasso monograph, by Maurice Raynal (Munich) is published. Picasso paints monumental compositions, including *Three Musicians*.

1922–1924 The Galerie Thannhauser in Munich stages a solo exhibition in autumn 1922. In December, *Antigone* is premiered in Paris: Picasso designs the set, Coco Chanel the costumes. In May 1923 *The Arts* in New York publishes the first important interview with Picasso. He takes an increasing interest in photography. For the ballet *Mercure* he designs costumes and sets which attract criticism. As a reaction, Surrealists such as André Breton and Max Ernst publish an *Hommage à Picasso* in the *Paris-Journal*.

1925/26 Conflicts with Olga increase, and are reflected in the painting *The Dance*. In November, works by Picasso are included in the first group exhibition by Surrealist painters, "La Peinture Surréaliste", at the Galerie Pierre in Paris. A long-term friendship develops in early 1926 between Christian Zervos, the founder of the magazine *Cahiers d'Art*, and Picasso. In June/July, the Galerie Rosenberg in Paris exhibits works by Picasso painted in the last 20 years.

1927–1929 Outside the Galeries Lafayette in Paris, Picasso invites the 17-year-old Marie-Thérèse Walter to model for him. She becomes his secret lover. In 1928 Picasso makes contact with the sculptor Julio González once more and learns the technique of welding from him in order to create metal sculptures. In 1929 he meets the Spanish painter Salvador Dalí.

1930/31 In January *Painting in Paris* the first special exhibition by the New York Museum of Modern Art (MoMA) displays 14 works by Picasso, while in London the following year the great retrospective *Thirty Years of Pablo Picasso* is staged. Picasso sets up a sculpture studio in his new home to the north of Paris, the Château de Boisgeloup. His relationship with Marie-Thérèse is reflected in many of his works, including *The Sculptor*. In 1931 Picasso produces illustrated editions of Ovid's *Metamorphoses* and Honoré de Balzac's artist novel *The Unknown Masterpiece*.

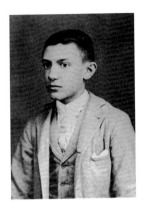

39 Pablo (Ruiz) Picasso, Barcelona, 1895/96

40 Picasso (centre) with Mateu Fernández de Soto and Carlos Casagemas in Barcelona, c. 1900

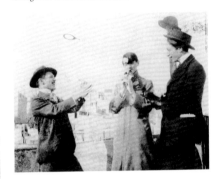

41 The Bateau-Lavoir with Picasso's note 'Window of my studio in Rue Ravignan 13', c. 1904

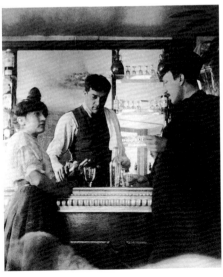

42 Fernande Olivier and Georges Braque in a Paris bar, c. 1908/10

1932/33 In May Picasso visits an exhibition of work by Alberto Giacometti, and a mutually inspirational friendship develops between them. To mark Picasso's 50th birthday, the largest retrospective to date is held at the Galerie Georges Petit in Paris, with 236 works on show. The exhibition gets overwhelmingly negative reviews in the press. In one article, the psychoanalyst C. G. Jung thought he detected signs of schizophrenia in Picasso's art. Alongside numerous graphic works on the theme of the sculptor's studio, Picasso creates others on the theme of the Minotaur, including the collage for the title page of the magazine *Minotaure*. Picasso tries in vain to prevent the publication of the memoirs of his former lover Fernande Olivier.

1934/35 In the summer of 1934 Picasso goes on a long trip to Spain with Olga and Paul. In June, the couple split up, although because of legal difficulties the planned divorce does not take place. On 5 October Marie-Thérèse gives birth to a daughter, María de la Concepción (Maya). Between May 1935 and the spring of 1936 Picasso paints no pictures, but starts to write and illustrate Surrealist poems. In November Sabartés returns from South America at Picasso's request and becomes his secretary.

1936–1938 After the outbreak of the Spanish Civil War on 18 July 1936, Picasso supports the Republicans against General Franco. He meets the Surrealist photographer Dora Maar, with whom he begins an erotic relationship. Together with Marie-Thérèse and Maya, he moves to Le Tremblay-sur-Mauldre, to the west of Paris. In April 1937, he begins work on *Guernica*, a monumental mural whose theme is the bombing of the Basque town of Guernica by the German Luftwaffe. It is intended for the Spanish Pavilion at the Paris World Fair.

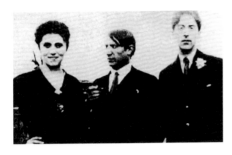

43 Olga Khokhlova, Picasso and
Jean Cocteau on tour with the
ballet *Parade* in Rome, 1917

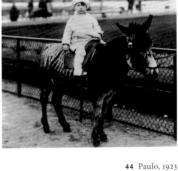

44 Paulo, 1923

45 Marie-Thérèse Walter, 1932

46 Maya in front of the
studio window in
Le Tremblay-sur-Mauldre
with Picasso at work, 1937

1939–1942 Picasso's mother dies on 13 January 1939. Picasso issues a written appeal on behalf of Spanish intellectuals imprisoned in the French town of Saint-Cyprien. In November 1939, the largest Picasso retrospective to date opens in the MoMA and lasts for two months. Through his friend the Surrealist poet Paul Eluard, in 1942 Picasso makes contact with the underground magazine *Les Lettres françaises*.

1943–1945 In May 1943 Picasso meets the young student Françoise Gilot. In 1944 he joins the French Communist Party. On 6 October the Salon d'Automne opens with a Picasso retrospective. The exhibition is heavily criticised. At the studio of Fernand Mourlot, to whom he was introduced by Braque, he learns the technique of lithography, which he uses for example in his series *The Bull*. He splits up with Dora Maar.

1946–1948 Together with Françoise, who has become his lover, Picasso visits Matisse in Nice. The museum in Antibes places rooms in the Palais Grimaldi at Picasso's disposal as a studio, where he paints, among other works, *La Joie de vivre*. He donates the pictures painted there to the museum, which is renamed Musée Picasso.

On 15 May 1947 Françoise gives birth to their son Claude. In August Picasso begins to take an intense interest in ceramics while in the southern French village of Vallauris, known for its pottery tradition. In the summer of 1948 he moves to a house nearby with Françoise and Claude.

1949–1952 The lithograph *The Dove* is chosen as the motif for the World Peace Conference to be held in Paris in April 1949. On 19 April his daughter Paloma is born. Alongside ceramics, he devotes himself in the autumn of 1950 even more intensively to sculpture, created assemblages of objets trouvés. In January 1951 he paints *Massacre in Korea*, a political protest against the Korean War and the American invasion. Relations with Françoise deteriorate in 1952, and he meets Jacqueline Roque.

47 Picasso in Vallauris, 1948

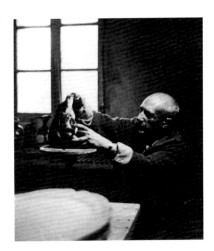

48 Picasso, Françoise and Picasso's
nephew, Javier Vilató, on the beach
at Antibes, 1948

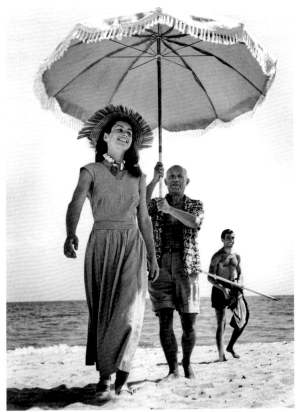

1953–1955 In January Picasso takes part in the exhibition *Le Cubisme* at the Musée national d'art moderne in Paris. For the magazine *Les Lettres françaises,* Picasso creates a portrait of Stalin on the basis of a youthful likeness to mark the death of the Soviet leader. The depiction is seen by the Communist Party not as homage, but as a caricature, and there are re-criminations. Françoise leaves Picasso and moves to Paris. At the beginning of 1954 Picasso meets Sylvette David, whom he portrays in some 40 drawings and paintings. In the course of the year he paints several portraits of Jacqueline, including *Portrait of Jacqueline Roque with Roses*. On 11 February 1955 Olga dies in Cannes. In the summer Picasso buys La Californie, a large property near Cannes.

1956–1959 Picasso celebrates his 75th birthday with the potters of Vallauris. In this and the following year, retrospectives to mark his birthday are held in New York, Chicago, Philadelphia and Arles, among other places. In 1957 he is commissioned by Unesco to paint the mural *The Fall of Icarus* for its new headquarters in Paris. In 1958 Picasso acquires the château de Vauvenargues near Aix-en-Provence as a second home.

1960–1962 The Tate Gallery in London stages a major retrospective in the summer, with 270 works. On 2 March 1961 Picasso and Jacqueline marry, and move into the villa of Notre-Dame-de-Vie near Mougins north of Cannes. There is a large celebration in Vallauris to mark the artist's 80th birthday. With undiminished energy he works on sculptures, drawings, lino-cuts and paintings. During 1962 he creates some 70 portraits of Jacqueline. In New York the exhibition *Picasso: An American Tribute* takes place in the spring of 1962, running in parallel in nine galleries.

1963–1965 The Museu Picasso opens in Barcelona in March. For his prints and etching cycles of the coming years Picasso begins a collaboration with the engravings studio of the Crommelynck brothers in Mougins. In 1964 Picasso tries, once again in vain, to prevent publications of the memoirs of a former lover, this time Françoise. In this and the following year the theme of the painter and his model remains current in Picasso's work. Together with Jacqueline he goes to Paris for the last time.

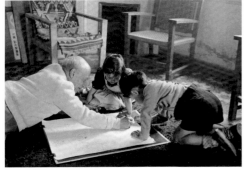

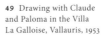

49 Drawing with Claude and Paloma in the Villa La Galloise, Vallauris, 1953

50 Picasso during a bullfight staged in his honour *La corrida de Picasso*, behind him his children Paloma, Maya and Claude along with Jean Cocteau, Vallauris, 1955

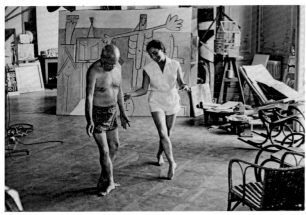

51 Picasso and Jacqueline dancing in front of *Bathers on the Beach at La Garoupe*, 1957

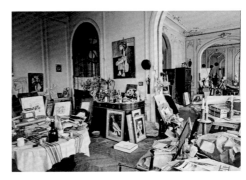

52 View of the salon in La Californie, 1957

1966–1969 To mark Picasso's 85th birthday, his hitherto largest retrospective *Hommage à Picasso* is opened in Paris on 19 November 1966 by his close friend, the Minister of Culture André Malraux. His secretary and friend Sabartés dies on 13 February 1968. In just seven months he produces 347 etchings, in which he addresses motifs from the circus, the bullfight, the commedia dell'arte as well as erotic themes. The following year he takes up the theme of couples in his paintings, e. g. in *The Kiss*.

1970–1973 Picasso donates some of his works to public museums, such as the Museu Picasso in Barcelona, the MoMA in New York and the Musée Réattu in Arles. To mark his 90th birthday, works by him are displayed in the Louvre between the Old Masters. He thus becomes the first living painter to be presented there. In 1972 he creates self-portraits suggesting a concern with his own death. On 8 April Picasso dies in Mougins, and is buried in Vauvenargues two days later.

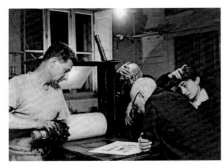

53 Jacqueline, Sabartés, Frélaut and Picasso examine a trial proof from the press in the basement of La Californie, 1957

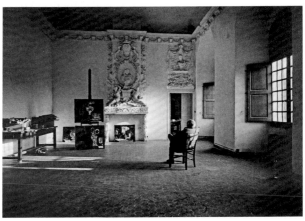

54 Picasso looking at his paintings in his studio in the salon of Château de Vauvenargues, 1959

55 Picasso with Jacqueline on the occasion of his 80th birthday in Vallauris, 1961

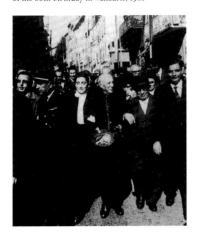

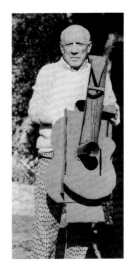

56 Picasso with *Guitar* (1912), which he later bequeathed to the Museum of Modern Art, 1971

Cahiers d'Art, nos. 7–10, 1935: *Picasso 1930–1935* (cover). In parallel
with an exhibition organised by ADLAN (Amigos de las Artes Nuevas)
in 1936 there appeared a magazine in which poems by Picasso were
published for the first time.

"Picasso and I said things to each other during these [Cubist] years that were never said again, [...] that no one will ever be able to understand, [...] things that would be incomprehensible, but which were a great joy to us [...] All this will end with us," recalled Georges Braque years later when thinking back to the time of his friendship and intense artistic dialogue with Picasso. During their close collaboration from 1908 to 1914 – "almost every evening either I went to Braque's studio or he to mine. Each of us simply had to see what the other had done during the day" – they maintained an absolute silence in public on anything that concerned their artistic discussions and thoughts. Their standpoint was that their works spoke for themselves.

The importance for Picasso of the exchange with Braque is demonstrated by the few surviving letters that he wrote to him between 1911 and 1913 when they were living in different places. "You promised to come here – don't forget. I have a lot to tell you." "Let me know when you're coming [...] and give me news about your painting." "I don't write to anyone about business matters except you and K[ahnweiler], and I only get letters from you, and I'm glad when you write, as you know very well." "I hope you'll tell me what you think of them [the pictures], especially the biggest one with the violin – I'm sure you understand the intention behind it."

Even during the lifetime of the two artists there were discussions about which of them had developed the Cubist style. While Kahnweiler described Picasso and Braque as being, in equal measure, "the first and greatest Cubists", noting that "in the development of this new art the contributions of both have been closely intertwined," Picasso's close friend the poet André Salmon singled Picasso out in his 1912 book *La jeune peinture française* as the crucial initiator of the style. "It treats you with outrageous injustice," wrote Picasso in a letter to Braque dated 31 October that year. And Braque too focused later on the shared, and mutually fruitful, achievement: "We compared ideas, pictures and techniques. Whatever sometimes piqued us, coming from the other, always soon bore fruit for both. Our friendship, then, was always profitable. [...] It was a connexion that rested on the independence of both."

The Great War put an end to this unusual artist friendship. Braque returned from the battlefield in 1916 with serious head wounds. Whether Picasso visited his friend during the latter's long convalescence in Sorgues

is not recorded. The dialogue between the two was at an end; their different personal and artistic developments, and their different circumstances, also played their part. Although they did meet a few times more, Picasso later told Kahnweiler that he had not seen Braque since he had accompanied him to the station at Avignon at the outbreak of the war. For Picasso it was the only period during which he entered into any such long-term emotional and artistic exchange.

2

Children exerted a great attraction for Picasso. He drew and painted his own and other people's children of all ages, above all babies and toddlers, rarely teenagers. He was fascinated and inspired by watching them grow, by their unspoilt nature, their freshness, their anarchic traits, and by their directness and spontaneity.

Picasso is largely described as a loving father who accorded his children every freedom as long as they did not disturb him while he was working, for then he could become "bad-tempered, vicious and unjust, but only towards those who deserved it," as his daughter Maya reported. He stimulated the children to wild adventures, but also to painting and drawing together, making things with their hands, or creating collages. Maya probably had the most harmonious childhood of all Picasso's offspring. After the conventional, society-oriented life with his wife Olga, whose relationship with him had broken down by the early 1930s, Picasso enjoyed the simple life with his muse and lover Marie-Thérèse, Maya's mother. "He was with me all day long," is how Marie-Thérèse described the period after the birth. "He did the washing, cooked the meals, saw to Maya, did everything except maybe make the beds." Even though the family idyll did not last long, as Picasso started a liaison with Dora Maar, Maya experienced her parents in a harmonious atmosphere. She assumed that the reason her father was so rarely with her and her mother was that he was working far from home. Her father "had a 'huge' sense of humour, and loved practical jokes," Maya recalled. "Thanks to him, I had sensational childish ailments. When I had measles, he painted pink spots on his face and dressed up as a clown. [...] We also played music hall. We sang the hits of 1900. Papa imitated and dressed up as Madame Arthur, with all the make-up."

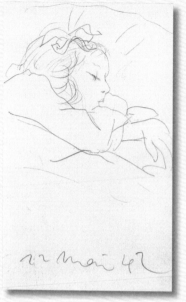

2

3

The works of the *Verve Suite* date from a difficult phase in Picasso's life. His lover Françoise Gilot had left him in 1953 after many years, moving to Paris with their two children Claude and Paloma. In spite of his loneliness – or maybe precisely because of it – in just a few weeks he created a series of 150 drawings, which were published in 1954 in a special issue of the magazine *Verve*. In the series, Picasso depicts the relationship of a painter to his model, and reflects among other things on his own age, voyeurism, erotic desire, and the concealment of identity.

In her memoirs *Life with Picasso* Françoise Gilot describes how she experienced the working atmosphere in Picasso's studio during the eight years or so of their relationship:

2 *The Artist's Daughter*, 1942, pencil on paper, private collection
3a, b *Verve Suite*, 10 January 1954 (XIV) and 25 January 1954 (I), heliogravure, both Clemens-Sels-Museum Neuss

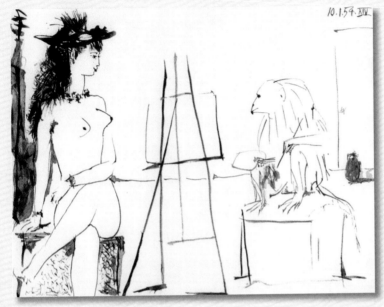

3a

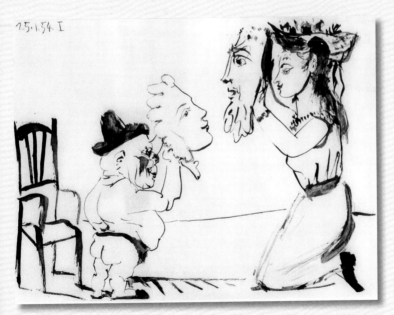

3b

" 'I almost never work from a model, but since you're here, maybe I ought to try,' he said to me one afternoon. He posed me on a low tabouret, then sat down on a long green wooden bench – the kind one sees in all the Paris parks. He picked up a large sketching pad and made three drawings of my head. When he had finished, he studied the results, then frowned. 'No good,' he said, 'it just doesn't work.' He tore up the drawings.

The next day he said: 'You'd be better posing for me nude.' When I had taken off my clothes, he had me stand back to the entrance, very erect, with my arms at my side. Except for the shaft of daylight coming in through the high windows at my right, the whole place was bathed in a dim uniform light. Pablo stood off three or four yards from me, looking tense and remote. His eyes didn't leave me for a second. He didn't touch his drawing pad. He wasn't even holding a pencil [...] Finally he said: 'I see what I need to. You can dress now. You won't have to pose again.' When I went to get my clothes, I saw that I had been standing there just over an hour. The next day Pablo began, from memory, a series of drawings of me in that pose."

4

"The flags frying in the pan writhe in the black of the ink sauce spilled in the drops of blood which shoot it," wrote Picasso in his 1937 political pamphlet *Sueño y mentira de Franco* ('The Dream and Lie of Franco'), which he illustrated with two etchings each with nine picture fields, and published as an artist book. In the depictions and the handwritten text that Picasso composed in the manner of a Surrealist poem without punctuation, he expressed his intention of bringing down Franco's regime with words and pictures, as well as his solidarity with the Spanish population.

Like many French intellectuals, shortly after the liberation of Paris in the summer of Picasso joined the French Communist Party, and he remained a member until his death.

"That I didn't officially join earlier was due to a certain naivety on my part. I always thought that my work, and the fact that I was there in my heart, would be enough. But it was already my party even then. [...] I've always been an exile, now I am no longer."

By this time Picasso was already the most important living artist, and now he also became a political personality with whom the left could identify.

4a

He made an active commitment on behalf of peace and freedom, making donations to humanitarian causes, supporting striking miners in northern France and Spanish Republicans in exile; he was a determined opponent of Apartheid in South Africa and spoke out against racism, inequality and oppression at various international peace congresses. In his visual work, his political commitment was manifested in paintings such as *Guernica*, *Massacre in Korea*, and *War and Peace*, and in a series of political posters, some of them to accompany disarmament and peace congresses.

Picasso dedicated his final poster, designed a year before his death, to imprisoned Spanish Republicans, who were to be the beneficiaries of the proceeds. The depiction of a proud bull against the colours of the republic

4a *Sueño y mentira de Franco* (The Dream and Lie of Franco), page of text, 1937, Museo Nacional Centro de Arte Reina Sofía, Madrid

4b

and the motif of the dove of peace gave expression to his hope for the triumph of democracy over the dictatorship of the Franco regime. Picasso had last visited his home country in 1934, and had resolved not to return until democracy was restored. He did not live to see this day, the first free elections being held in Spain only in 1977.

4b *Sueño y mentira de Franco* (The Dream and Lie of Franco), plate II, 1937, etching and aquatint, Museo Nacional Centro de Arte Reina Sofía, Madrid

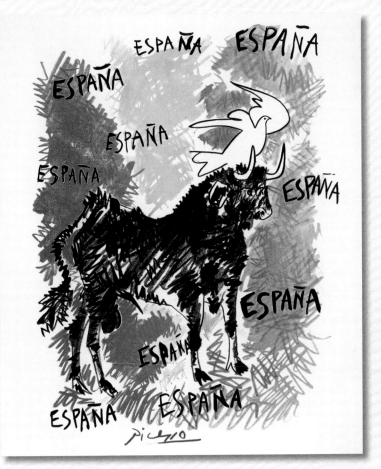

4c

4c *España*, poster, 1972

SOURCES

EXTRACTS WERE QUOTED FROM
THE FOLLOWING LITERARY SOURCES

William Rubin, *Picasso und Braque, Die Geburt
des Kubismus*, Munich 1990: 70
Françoise Gilot and Carlton Lake, *Life with
Picasso*, New York 1964: 107
Patrick O'Brian, *Pablo Ruiz Picasso, a Biography*,
London, 1979: 75
Johannes M. Fox, *Picassos Welt*, Halle 2008: 71/72

Published by

Hirmer Verlag GmbH
Nymphenburger Strasse 84
80636 Munich
Germany

Front cover: *Les Demoiselles d'Avignon* (detail),
1907, oil on canvas, Museum of Modern Art,
New York
Double page 2/3: *The Sculptor* (detail), 1931,
oil on plywood, Musée Picasso, Paris
Double page 4/5: *The Banderillas, Seated*
(*Tauromaquia*, sheet 15) (detail), 1957, aquatint,
Classen Collection in the KPPM

www.hirmerpublishers.com

—
TRANSLATION FROM THE GERMAN
Michael Scuffil, Leverkusen

—
COPY-EDITING/PROOFREADING
Jane Michael, Munich

—
PROJECT MANAGEMENT
Rainer Arnold

—
DESIGN/TYPESETTING
Marion Blomeyer, Rainald Schwarz, Munich

—
PRE-PRESS/REPRO
Reproline mediateam GmbH, Munich

—
PAPER
LuxoArt samt new

—
PRINTING/BINDING
Passavia Druckservice GmbH & Co. KG, Passau

The author wishes to thank Petra van Dillen and
Josephine Schilgen for their inspiring assistance
in the choice of pictures.

Bibliographic information published by the
Deutsche Nationalbibliothek
The Deutsche Nationalbibliothek lists this
publication in the Deutsche Nationalbibliografie;
detailed bibliographic data are available on the
Internet at http://dnb.dnb.de .

ISBN 978-3-7774-2757-7
Printed in Germany